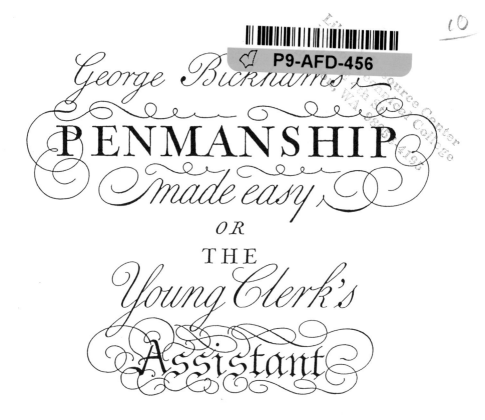

George Bickham's

PENMANSHIP

made easy

OR

THE

Young Clerk's Assistant

DOVER PUBLICATIONS, INC.
Mineola, New York

Published in Canada by General Publishing Company, Ltd., 30 Lesmill Road, Don Mills, Toronto, Ontario.

Published in the United Kingdom by Constable and Company, Ltd., 3 The Lanchesters, 162–164 Fulham Palace Road, London W6 9ER.

Bibliographical Note

This Dover edition, first published in 1997, is a reprint of a work originally published ca. 1733.

Library of Congress Cataloging-in-Publication Data

Bickham, George, 1684?–1758?
 [Young clerk's assistant]
 George Bickham's Penmanship made easy (The young clerk's assistant) / by George Bickham.
 p. cm.
 Originally published: The young clerk's assistant, or, Penmanship made easy. London : Printed for Richard Ware, ca. 1733.
 ISBN 0-486-29779-9 (pbk.)
 1. Penmanship. 2. Commercial correspondence–Great Britain. I. Title.
Z43.B583 1997
652'.1–dc21 97–16502
 CIP

Manufactured in the United States of America
Dover Publications, Inc., 31 East 2nd Street, Mineola, N.Y. 11501

Directions

for

Young Practitioners

by Way of

Introduction.

Writing will never look Orna-
-mental without a due proportion of the
Characters throughout the Whole, a just
Distance between the Letters themselves
as well as the Words, a Natural inclination
of one Letter to another, & a Smooth Stroke
perform'd with boldness & freedom

Directions for Learners

The proportion of Letters is regulated by the O & N; therefore practise them first in a large Character.

Make All Your Body-Strokes with the Full, & all Hair-Strokes with the corner of Your Pen.

Never turn Your Pen, nor alter the Position of Your hand.

Let Your hair-Strokes be proportion'd to Your Body-Strokes & answer one another.

Your Letters without Stems must be even at top & bottom.

Let Your Stems above be equal in length to l (t only excepted)

Your Stems below must be equal in length to j.

Let Your Capitals be equal in height

Directions for Learners

to l, & a little Stronger.

Let Your Words stand twice y distance of Letters, & y Lines twice the length of l, that no Stems may interfere..

Hold Your Pen between the two fore-fingers extended almost strait, & the Thumb bending outward, with y hollow downwards, & the Nib flat.

Let Your Paper lie directly before you. & your Hand rest only on y top of y little Finger.

Rest Your Arm lightly between the Wrist & the Elbow.

Keep Your Body upright, and your Elbow almost close to your Side.

Rest Your Body on your left Arm, & keep your Paper down with your left Hand.

Never lean hard on your Pen

Directions for Learners

In Order to Write expeditiously in time, Write slow at first.

Make the Nib of your Pen for the Round & Round-Text Hands the breadth of the full Stroke, & that part lying next y̆ Hand Something Shorter & Narrower.

For the Italian Hand make the Nib something finer, & the Slit longer.

Note In Writing where Figures are intermix'd, they must always Slope.

Your Figures likewise must be larger than Your Writing.

When Your Figures are rang'd in Columns, make them upright.

I shall close these Useful Hints with Mr. Motteux's Encomium on the Pen, & humbly hope, 'twill meet with a favourable Reception, not only as an agreeable amusem.t but as a suitable Dedication to an Undertaking of this Nature.

THE
#
TO THE
YOUNG CLERKS
of
Great Britain.

Ye British Youth, Our Ages hope & Care;
You, whom the Next may polish or impair,
Learn by the **Pen** those Talents to infure,
That fix ev'n Fortune, & from Want Secure.
You, with a Dash, in time may drein a Mine,
And deal the Fate of Empires in a Line.
For Ease & Wealth, for Honour & Delight,
Your Hands Your Warrant, if you well can write.

Vive la Plume.

TO THE
YOUNG LADIES
of
𝕲𝖗𝖊𝖆𝖙 = 𝕭𝖗𝖎𝖙𝖆𝖎𝖓.

Ye Springing Fair, whom gentle Minds incline
To all that's curious innocent and fine:
With Admiration in your Works are read
The various Textures of the twining Thread:
Then let the Fingers, whose unrivall'd Skill
Exalts the Needle, grace the Noble Quill.
An artless Scrawl the blushing Scribler Shames;
All should be fair that beauteous Woman frames
Strive to excel, with ease the Pen will move,
And pretty Lines add charms to Infant Love.

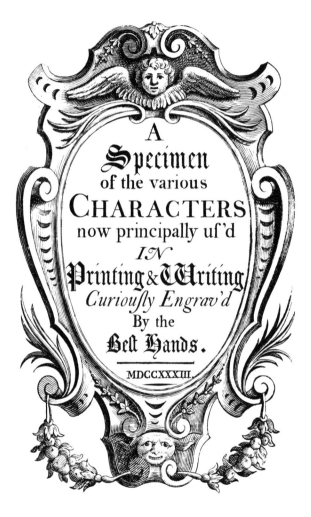

A

𝕾pecimen
of the various
CHARACTERS
now principally uſ'd
IN
𝕻rinting & 𝖂riting
Curiouſly Engrav'd
By the
𝕭eſt 𝕳ands.

MDCCXXXIII.

THE Alphabet in the Old English CHARACTER.

Nº.	Form	Power & Measure	Nº.	Form	Power & Measure
1	A a	ā	14	N n	ĕn
2	B b	bē	15	O o	ō
3	C c	fēe	16	P p	pēe
4	D d	dēe	17	Q q	cu
5	E e	ē	18	R r	ăr
6	F f	ĕf	19	S s	ĕſs
7	G g	gēe	20	T t	tēe
8	H h	atch	21	U u	yu or ū
9	J	ī	22	v	vâu
10	j	jŏd or jāy	23	W w	doū.yu
11	K k	ka	24	X x	ĕx
12	L l	ĕl	25	Y y	wȳ
13	M m	ĕm	26	Z ʒ	zĕd or ĕz

THE
Alphabet,
in the
ROMAN and ITALIC
Characters.

N°.	Roman.	*Italic.*	N°.	Roman.	*Italic.*
I	A a	*A a*	XIV	N n	*N n*
II	B b	*B b*	XV	O o	*O o*
III	C c	*C c*	XVI	P p	*P p*
IV	D d	*D d*	XVII	Q q	*Q q*
V	E e	*E e*	XVIII	R r	*R r*
VI	F f	*F ſ*	XIX	S ſs	*S ſs*
VII	G g	*G g*	XX	T t	*T t*
VIII	H h	*H h*	XXI	U u	*U u*
IX	I i	*I i*	XXII	V v	*V v*
X	J j	*J j*	XXIII	W w	*W w*
XI	K k	*K k*	XXIV	X x	*X x*
XII	L l	*L l*	XXV	Y y	*Y y*
XIII	M m	*M m*	XXVI	Z z	*Z z*

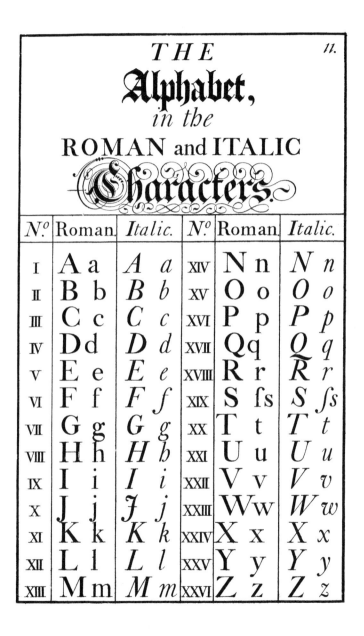

THE
Alphabet
in the
Round-hand *and* Italian.

N.º	Round-hand	Italian	N.º	Round-hand	Italian
1	Aaa	Aaa	14	Nnn	Nnn
2	Bbb	Bbb	15	Oooo	Oooo
3	Cccc	Cccc	16	Ppp	Ppp
4	Ddd	Ddd	17	Qqq	Qqqq
5	Eeee	Eeee	18	Rrr	Rrr
6	Ffff	Ffff	19	Lsſs	Jsſs
7	Ggg	Gggg	20	Ttt	Tttt
8	Hhh	Hhh	21	Uuu	Uuu
9	Iiü	Iiü	22	Vvv	Vvv
10	Jjjj	Jjjj	23	Ww	Www
11	Kkk	Kkk	24	Xxx	Xxx
12	Llll	Llll	25	Yyy	Yyy
13	Mmm	Mmm	26	Zzz	Zzz

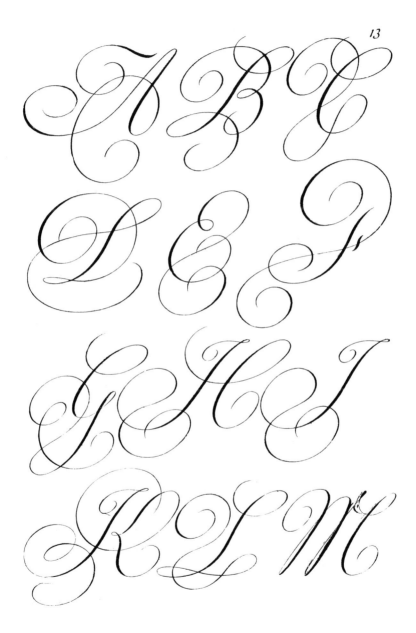

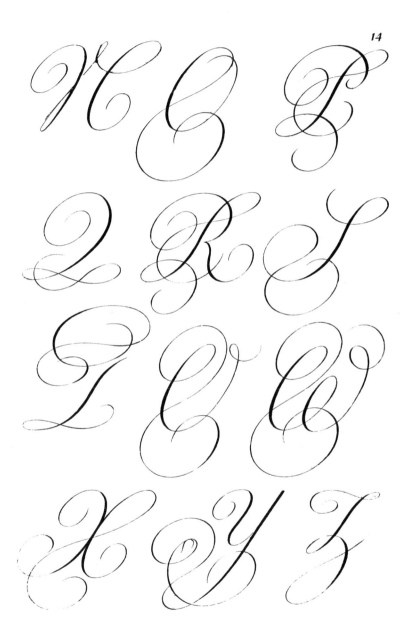

MINUMS
In Round-hand and Italian.

Round-hand.	Italian.	Round-hand	Italian.
Aama	Aama	Nnm	Nnmn
Bbmb	Bbmb	Oomo	Oomoo
Ccmcc	Ccmcc	Ppmp	Ppmpp
Ddmd	Ddmd	Qqmq	Qqmq
Eemee	Eemee	Rrmr	Rrmr
Ffmff	Ffmff	Ssmfs	Ssmfs
Ggmgg	Ggmgi	Ttmtt	Ttmtt
Hhmh	Hhmh	UuVvi	UuVvm
Iimij	Iimiji	Wnm	Wvmw
Kkmk	Kkmk	Xxmx	Xxmx
Llmll	Llmll	Yymy	Yymy
Mmm	Mmm	Zzzm.	Zzmz

1234567890. 1234567890.
1234567890.

THE

Alphabet in Single Copies

Prize exquisite workmanship, & be carefully diligent.

Knowledge shall be promoted by frequent exercize.

Quicksighted men by exercize will gain Perfection.

Happy hours are quickly followed by amazing vexations.

Moral Maxims

Alphabetically digested

for the

Practice of Youth

in the

Round-hand.

Art polishes and improves nature.

Beauty's a fair but fading flower.

Content alone is true happiness.

Delays often ruin the best designs.

Encouragement's the life of action.

Fortune's a fair but fickle mistress.

Grandeur is no true happiness.

Health is life's choicest blessing.

Indolence is an inlet to every vice.

Knowledge is a godlike attribute.

Liberty is an invaluable blessing.

Modest merit finds but few admirers.

Necessity is the mother of invention.

One bad Sheep infects a whole flock.

Pride is a passion not made for man.

Quick resentments prove often fatal.

Riches are precarious blessings.

Self-love is the bane of Society.

The hope of reward sweetens labour.

Variety is the beauty of the world.

Writing is a fine accomplishment.

X, Excefs kills more than the Sword.

Yesterday mispent can't be recall'd.

Zeal misapply'd is pious phrenzy.

Moral Maxims

Alphabetically digested

FOR THE

Practice of the Ladies in

The ITALIAN HAND.

Affectation ruins the finest face

Beauties very Seldom hear the Truth.

Conscious Virtue is its own Reward.

Dreams are the Pastimes of Fancy.

Envy too often attends true Merit.

Fame once lost can never be regain'd.

Good-humour has everlasting Graces.

Humility adds charms to Beauty.

Innocence is ever gay and chearful.

Knowledge procures general Esteem.

Love hides a Multitude of Faults.

Modesty charms more than Beauty.

Nothing is more valuable than Time.

Order makes Trifles appear graceful.

Praise is grateful to human Nature.

Quick Promisers are slow Performers.

Recreations, if innocent, are lawful.

Shame attends unlawful Pleasures.

Truth needs no disguise or Ornament.

Vanity makes Beauty contemptible.

Wisdom is more valuable than Riches.

X Examples sway more than Precepts.

Youth, like Beauty, very soon decays.

Zeal warms, and enlivens Devotion.

Moral Distichs

in

Round-hand & Italian.

Devotion is the soul's securest guard,
And conscious virtue is it's own reward.

From science only true content can flow,
For 'tis a godlike attribute to know.

Beauties, like princes, from their very youth,
Are perfect strangers to the voice of truth.

In beauty, the least faults conspicuous grow,
Each speck, at the first glance, is seen on snow.

Advice
to
Young Gentlemen

At every Trifle scorn to take offence
That always shews great pride, or little sense.
Good nature, and good sense must ever joyn;
To err is human, to forgive divine.

Advice to the Ladies

Trust not too much your now resistless charms;
Those, age or sickness soon or late disarms:
Good humour only teaches charms to last,
Still makes new conquests, & maintains y.º past.

Advice
to
Young Gentlemen.

Law suits avoid with as much studious Care,
As you would Dens, where hungry Lions are;
And rather put up Injuries, than be
A Plague to Him, who'd be a Plague to Thee:
Value your Quiet at a Price too great
For a revenge, to give so dear a Rate.

Advice to the Ladies.

Tho' Lovers oft extol your Beauty's Power,
And in celestial Similies adore;
Tho' from your Features Cupid borrows Arms,
And Goddesses confess inferiour Charms,
Do not, vain Maid! the flatt'ring Tale believe;
Alike thy Lovers, and thy Glass, deceive.

Envy

always pursues,
True Merit.

Envy will merit as its shade pursue;

But like a shadow proves ÿ substance true.

For envy'd wit, like Sol eclips'd, makes known

Th'opposing body's grossness, not its own.

When first that sun too pow'rful beams displays,

It draws up vapours which obscure its rays;

But ev'n those clouds at last adorn its way,

Reflect new glories, and augment the day.

On the particular Advantages arising from Epistolary Writing.

Heav'n first taught letters for some wretch's aid,
Some banish'd lover, or some captive maid.
They live, they speak, they breath w.^t love inspires,
Warm from the soul, and faithful to its fires;
The virgin's wish without her fears impart,
Excuse the blush, and pour out all the heart.
Speed the soft intercourse from soul to soul,
And waft a sigh from Indus to the pole.

On the
General Advantages
of
Reading & Writing.

'Tis to the press and pen we mortals owe

All we believe, and almost all we know.

All hail! ye great preservers of those arts,

That raise our thoughts, & cultivate our parts.

Had your assistance been to man deny'd,

All wit alas! in oral sounds had dy'd.

You bring past wonders to our present view;

Homer and Virgil live alone in you.

Their tuneful numbers had long since decay'd,

And lost their native charms without ÿ Aid.

The
Days of the Week

Round Text.	Italian Text.
Sunday.	Sunday.
Monday.	Monday.
Tuesday.	Tuesday.
Wednesday.	Wednesday.
Thursday.	Thursday.
Fryday.	Fryday.
Saturday.	Saturday.

London. Anno Dom. 1733.

The
Months in the Year
In Round Text.

	Days		Days
January.	31	July......	31
February.	28	August..	31
March.	31	September..	30
April...	30	October..	31
May....	31	November...	30
June.....	30	December...	31

Thirty Days hath September
April June and November
And all the rest have Thirty one,
Save February, which alone
Has Twenty Eight; and one Day more
Is added to't One Year in four.

Christian Names
in
Round-hand.

Alexander.	Matthew.
Benjamin.	Nathaniel.
Christopher.	Obadiah.
Daniel.	Philip.
Edmund.	Quintilian.
Frederick.	Richard.
George.	Samuel.
Henry.	Thomas.
Joseph.	Vincent.
Kenric.	William.
Leonard.	Zachary.

Christian Names
in the
Italian-hand

Arabella	Martha
Beatrice	Nichola
Charlotte	Olivia
Dorothy	Priscilla
Elizabeth	Quintiliana
Frances	Rachel
Grace	Susanna
Hannah	Theodosia
Joanna	Ursula
Katharine	Winifred
Louisa	Zenobia

The ALPHABET in the
SQUARE HANDS.

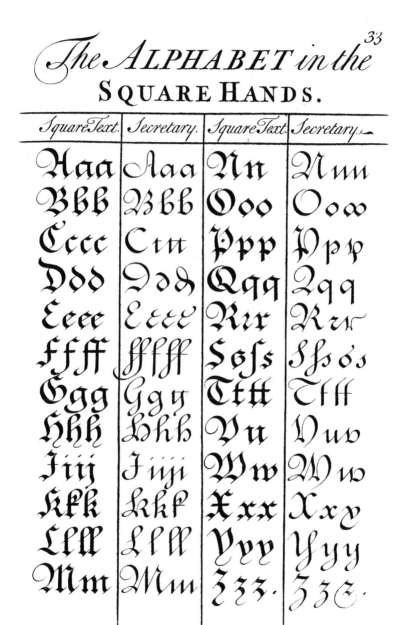

SquareText.	Secretary.	SquareText.	Secretary.
Aaa	Aaa	Nn	Nnn
Bbb	Bbb	Ooo	Ooo
Cccc	Cttt	Ppp	Ppp
Ddd	Ddd	Qqq	Qqq
Eeee	Eeee	Rrr	Rrr
Ffff	ffff	Sefs	Sfss
Ggg	Gqy	Tttt	Tttt
Hhh	Hhh	Vu	Vuv
Iiij	Iiiji	Ww	Ww
Kkk	Kkk	Xxx	Xxy
Lllll	Lllll	Yyy	Yyy
Mm	Mm	Zzz.	Zzz.

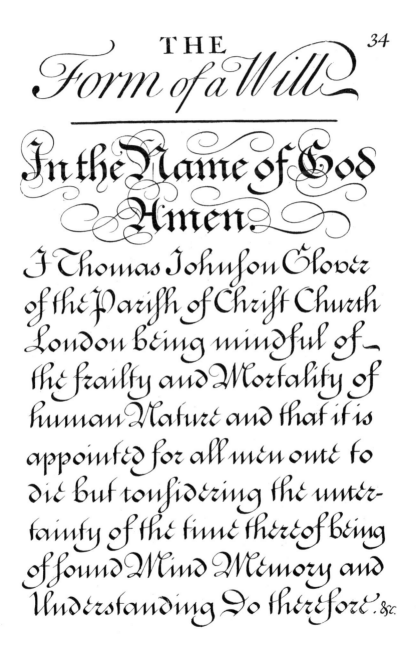

THE
Form of a Will

In the Name of God Amen.

I Thomas Johnson Glover
of the Parish of Christ Church
London being mindful of
the frailty and Mortality of
human Nature and that it is
appointed for all men once to
die but considering the uncer-
tainty of the time thereof being
of sound Mind Memory and
Understanding Do therefore. &c.

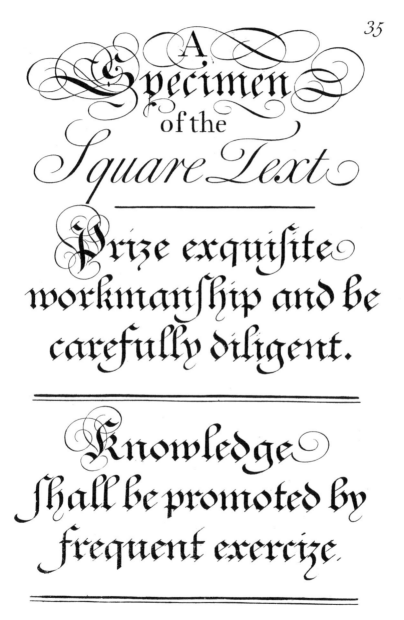

A
Specimen
of the
Square Text

Prize exquisite
workmanſhip and be
carefully diligent.

Knowledge
ſhall be promoted by
frequent exercize.

German Text

Aabcdeffghijkllm
nop qrsſ sttuvwxyz.

ABCDEFGH
IKLMNOPQ
RSTVWXYZ.

Variety is the
Beauty of the World

FINIS.

THE

Virgin Muſe;

OR

SELECT POEMS

ON

Several Occaſions

Moral and Divine:

ENGRAV'D

For the particular

PRACTICE and AMUSEMENT

OF THE

FAIR SEX.

Immodeſt Verſe admits of no Defence
For Want of Decency is Want of Senſe. Roſc.

LONDON:

Printed for Richard Ware at the Bible & Sun
in Amen-Corner, Warwick Lane.

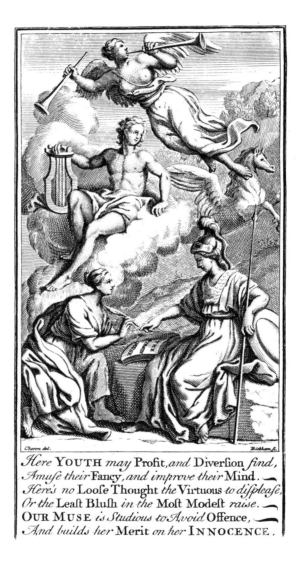

Cheron del. Bickham sc.

Here YOUTH *may* Profit, *and* Diversion *find,*
Amuse their Fancy, *and improve their* Mind.
Here's no Loose Thought *the* Virtuous *to displease,*
Or the Least Blush *in the* Most Modest *raise.*
OUR MUSE *is* Studious *to* Avoid Offence,
And builds her Merit *on her* INNOCENCE.

THE Governess; OR, INNOCENCE SECUR'D.

A SIMILE.

As when blith Lambs their Vernal Revels keep,
Bound from the Turf, & o'er the Hillocks leap,
Now harmless try to butt, then run away;
Now weary'd feed, and thus consume y̆ day;
Th'indulgent Shepherdess attentive lies,
Lest from y̆ Woods some sudden Foe should rise,
And, as they play, her harmless Flock surprize.
So, the Sage Governess, whose constant care,
By Wisdom's dictates forms y̆ tender Fair,
When her gay Female Throng, to Sport inclin'd,
Suspend the Nobler Pleasures of the Mind;
With jealous Eyes each motion does Survey,
Lest they should Swerve from Virtue in their Play.

Art improves Nature,

OR, THE

Force of Education

How fair & sweet the planted Rose,
Beyond the wild in Hedges grows!
For without Art the Noblest Seeds
Of Flow'rs degenerate to Weeds.
How dull & rugged e'er tis ground
And polish'd, looks a Diamond!
Tho Paradise was e'er so fair,
It was'nt kept so without Care.
The whole World, without Art & Dress,
Would be but one great Wilderness;
And Mankind but a Savage Herd,
For all that Nature has confer'd;
She does but rough hew and design,
Leaves Art to polish and refine.

EUDOSIA;

OR, THE

Accomplish'd Virgin.

From guiltleſs Dreams prepar'd to pray,
The Virtuous Maid prevents the Day:
Aurora blushes when She Sees
The earlier Virgin on her Knees.
 Now to her Morning Task She flies,
Which Pallas views with envious Eyes,
And forms in Wax So gay a Feast,
That Jove himſelf might long to taste.
 Her glaring Tent next Strikes our Eyes
With an Agreeable Surprize;
Where the bold Figures Seem to live,
And whilst they charm, instruction give.
Some Story's told in every Thread,
And in each Stitch ſome Moral's read.

Content alone is true happiness;

OR, THE

Country Lass.

What happiness the rural Maid attends
In chearful Labour while each day she spends!
She gratefully receives what Heav'n has sent,
And, rich in Poverty, enjoys Content.
She never feels y Spleen's imagin'd Pains;
Nor Melancholy Stagnates in her Veins;
She never loses Life in thoughtless Ease,
Nor on the velvet Couch invites disease;
Her home-spun Dress in simple Nature lies,
And for no glaring Equipage she sighs:
Her Reputation which is all her Boast,
In a malicious Visit ne'er was lost.
No midnight-Masquerade her Beauty wears,
And Health, not Paint, y fading Bloom repairs.

THE
𝕱air Architect:
OR THE
ARTIFICIAL GROVE.

I. What hand, Florella, or what Art
 Is equal to thy Thought?
What Grove before was ever seen
 So exquisitely wrought?

II. Thy chequer'd Stones, Thy glittring Shells,
 In Such proportion rise;
Like Piles by incantation rais'd,
 They captivate our Eyes.

III. The Stones which Thebes fam'd walls compos'd,
 Tho' rang'd by Art divine,
Were not so curious, So Compleat,
 So well dispos'd as Thine.

IV. Not Iris, when her painted Bow
 Adorns the watry Skies,
Can boast those Particolour'd Charms,
 Which in thy Grotto rise.

V. For Ages past his Eden lost,
 In vain has Man deplor'd:
But now we see thy magic hand
 Has Paradise restor'd.

Wealth without Content;

OR, THE

Unhappy Marriage.

The Gods to curse Pamela with her pray'rs,

Gave the gilt Coach, & dappled Flanders Mares,

The Shining Robes, rich Jewels, Beds of State,

And to compleat her Bliss, a Fool for Mate.

She glares in Balls, Front-Boxes, & the Ring,

A vain, unquiet, glitt'ring, wretched Thing.

Pride, Pomp & State but reach her outward part,

She Sighs, and is no Dutchess at her heart.

THE
INCONSTANT.

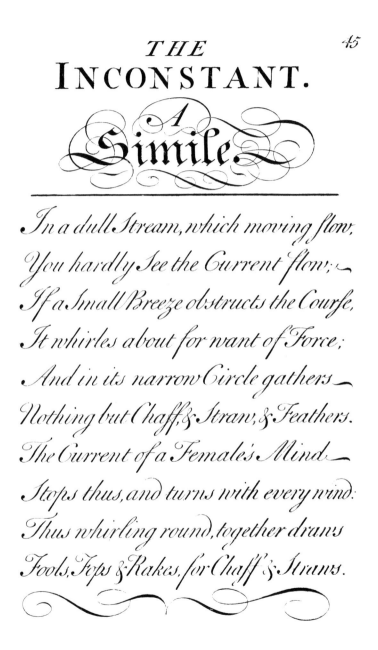

A Simile.

In a dull Stream, which moving flow,
You hardly See the Current flow;
If a small Breeze obstructs the Course,
It whirles about for want of Force;
And in its narrow Circle gathers
Nothing but Chaff, & Straw, & Feathers.
The Current of a Female's Mind
Stops thus, and turns with every wind:
Thus whirling round, together draws
Fools, Fops & Rakes, for Chaff & Straws.

Sympathetic Love;

OR,

Fancy surpasses Beauty.

Who e'er excels in what we prize,

Appears a Hero in our Eyes.

Each Girl, when pleas'd n:th what is taught,

Will have the Teacher in her Thought.

When Miss delights in her Spinet,

A Fiddler may a Fortune get.

A Blockhead, with melodious Voice,

In Boarding-Schools can have his choice:

And oft the Dancing-Master's Art

Climbs from y'e Toe to reach the Heart.

In Learning let the Nymph delight,

The Pedant gets a Mistress by't

THE
Happy Beau;
OR, THE
Ladies Favourite.

How happy lives y Man, how sure to charm,
Whose Knot embroider'd flutters down his Arm!
On him the Ladies cast the Yielding Glance,
Sigh in his Song, & languish in his Dance.
While wretched is y Wit, contemn'd, forlorn,
Whose gummy Hat no scarlet Plumes adorn.
What tho' Apollo dictates from his Tongue,
No Lady's Favour on his Sword is hung.
His Wit is Spiritless, and void of Grace,
Who wants th' assurance of Brocade & Lace.
While the gay Fop genteely talks of weather,
The Fair in raptures doat upon his Feather.
He dresses, fences;——What avails to know?
For Women chuse their Men, like silks, for shew.

Beauty's a fair but fading Flower,[48]
OR, THE
ROSE.

I.
Go, lovely Rose,
Tell her that wasts her Time and me,
That now she knows,
When I resemble her to Thee,
How Sweet and fair she seems to be.

II.
Tell her that's Young,
And Shuns to have her Graces Spy'd,
That hadst thou sprung
In Desarts where no Men abide,
Thou must have uncommended dy'd.

III.
Small is the worth
Of Beauty from the Light retir'd;
Bid her come forth,
Suffer herself to be desir'd,
And not blush so to be admir'd.

IV.
Then die, that She
The common Fate of all Things rare
May read in Thee;
How small a part of Time they share,
Who are so wondrous sweet and fair.

An Idea of Wedlock

Antient & Modern.

In antient times (as Poets Sing)
Love was a great, a glorious Thing;
A Fire Celestial & refin'd,
That warm'd with chast desires y.e Mind;
But now-adays no female Heart
Is Captivated by Desert; ————
The wealthy Fool, in gaudy Dress,
Alone can hope to find Success.
Love-Vows are now all Cant & Jargon,
And Wedlock grown a Smithfield Bargain.

ADVICE to the LADIES.

Learn how to value Merit, tho' in Rags,
And scorn the proud, ill-manner'd Fool in Office.
OTWAY.

Virgins should value nothing lefs
Than Titles, Figures, Shape and Drefs.
Merit should be forever plac'd
In Judgment, Knowledge, Wit & Taft.
For thefe, 'tis own'd, without dispute,
Alone distinguish Man from Brute.
A Wealthy, gawdy Fool can pafs
At best, but for a Golden Afs.

Ill habits are hard to be remov'd;

OR THE

Prejudice of Education;

A SIMILE.

As Plants, whilst tender, bend which way we please,
And are, tho' crooked first, made strait with ease;
Yet, if those Plants to their full Stature grow
Irregular, they'l break before they'l bow:
Thus Youth, set right at first, with Ease go on,
And each new Task is with new Pleasure done;
But if neglected till they grow in Years,
And each fond Mother her dear Darling Spares,
Error becomes habitual, and we find
'Tis. then, hard Labour to reform the Mind.

THE

Young Ladies
Address to Piety.

Hail' gentle Piety.' unmingled joy;——
Whose fulness Satisfies, but neer can cloy!
Spread thy soft Wings o'er my devoted Breast,
And settle there an everlasting Guest.'——

 Not cooling breezes to the languid Swain,
To Winter Sun-shine, or to Summer Rain,
To sinking Mariners the friendly hand,
That bears them up, & guides 'em safe to Land,
Bring half the Comfort, or the welcome find,
As thy Accesses to a Shipwreck'd Mind.

On the POSSIBILITY of the
Salvation of the Heathens

God's boundless Goodness, boundless Mercy may —
Find ev'n for those bewildred Souls a Way: —
If from his Nature Foes may Pity claim, —
Much more may Strangers who ne'er heard his Name:
And tho' no Way be for Salvation known, —
But that of his *Eternal Son* alone, —
Who knows how far transcendent Goodness can
Extend the Merits of that *Son* to *Man*? —
Who knows what Reasons may his Mercy lead,
And Ignorance invincible may plead? —
Not only Charity bids hope the best; —
But more the great *Apostle* has exprest: —
To Nature's plain Indictments they shall plead,
And by their Conscience be condemn'd or freed.
Most righteous Doom! because a Rule reveal'd
Is none to those from whom it is conceal'd. —
Then Those, who follow'd Nature's Dictates right,
Liv'd up, & lifted high their Natral Light,
With *Socrates* may see their *Maker's* Face,
Whilst thousand Rubric-Martyrs want a place

ON THE
REDEMPTION of MANKIND,
by our ever blessed
Lord and Saviour,
Jesus Christ

When in old Times th'Almighty Father sat
In Council to redeem our ruin'd State,
Millions of Millions at a distance round
Silent the Sacred Consistory Crown'd,
To hear what Mercy mixt with Justice could, *Propound.*
All prompt with eager Pity to fulfil
The full Extent of their Creator's will:
But when the Stern Conditions were declar'd,
A mournful whisper thro'y̆ Host was heard;
And y̆ whole Hirarchy with Heads hung down,
Submissively declin'd y̆ pondrous, proffer'd *Crown;*
Then, not till then, th'Eternal Son from high
Rose in the strength of all the Deity;
Stood forth t'accept the Terms, & underwent
A Weight, which all y̆ Frame of Heaven had bent.
Nor he himself could bear, but as Omnipotent.

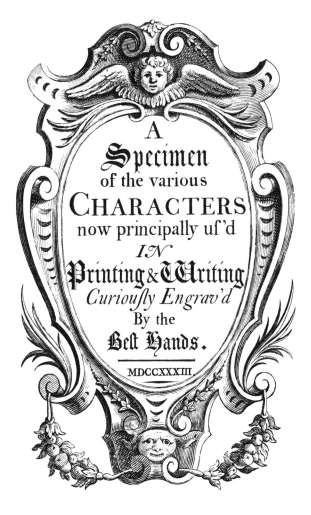

A
𝖘𝖕𝖊𝖈𝖎𝖒𝖊𝖓
of the various
CHARACTERS
now principally uſ'd
IN
𝖕𝖗𝖎𝖓𝖙𝖎𝖓𝖌 & 𝖂𝖗𝖎𝖙𝖎𝖓𝖌
Curiouſly Engrav'd
By the
𝕭𝖊𝖘𝖙 𝕳𝖆𝖓𝖉𝖘.

MDCCXXXIII.

FELICIA:

OR THE

Happy Virgin.

i

HER Life alone is greatly blest,
　　Whom no intruding Griefs annoy;
Who smiles each happy Day, possest
　　Of chearful Ease, and guiltless Joy:
Nor sadly soothing her own Cares,
　　Augments herself the Weight she bears.

ij

Pleas'd with a few selected Friends,
　　She views each smiling Ev'ning close;
While each succeeding Morn ascends,
　　Charg'd with Delights, unmixt with Woes:
In Pleasures innocently gay,
　　Wears her Remains of Life away.

THE

ROSE.

By Mr. *GAY.*

I

GO, *Rose,* my *CHLOE*'s Bosom grace ;
 How happy should I prove,
Might I supply that envy'd Place
 With never-fading Love !
There, *Phœnix*-like, beneath her Eye,
Involv'd in Fragrance, burn and dye !

II

Know, hapless *Flower*, that thou shalt find
 More fragrant Roses there ;
I see thy with'ring Head reclin'd
 With Envy and Despair !
One common Fate we both must prove ;
You dye with *Envy,* I with *Love.*

Young Lady's

F A N.

By Dr. *A T T E R B U R Y*, Late
Biſhop of *Rocheſter*

FLAVIA, *the leaſt and ſlighteſt* TOY,
 Can with reſiſtleſs Art employ.
This FAN, *in meaner Hands, would prove*
An ENGINE *of ſmall Force in Love*;
Yet SHE, *with graceful Air and Mien*,
(Not to be told or ſafely ſeen)
Directs its wanton Motions ſo,
That it wounds more than CUPID's *Bow*;
Gives Coolneſs to the matchleſs DAME,
To every other Breaſt——— a FLAME.

THE
Invocation;
OR, THE
Morning Sacrifice.

I. O God! my Heart is fix'd, 'tis bent
 Its thankful Tribute to present;
 And with my Heart, my Voice I'll raise
 To thee, my God, in Songs of Praise.

II. Awake, my Glory, Harp, and Lute;
 No longer let your Strings be mute;
 And I, my tuneful Part to take,
 Will with the early Dawn awake.

III. Thy Praises, Lord, I will resound,
 To all the list'ning Nations round:
 Thy Mercy highest Heav'n transcends;
 Thy Truth beyond the Clouds extends.

IV. Be thou, O God! exalted high;
 And as thy Glory fills the Sky,
 So let it be on Earth display'd,
 Till thou art here, as there obey'd.

THE Thanksgiving; OR, THE Ev'ning Sacrifice.

I.

Through every Period of my Life
Thy Goodness I'll pursue,
And after Death, in distant Worlds,
The glorious Theme renew.

II.

When Nature fails, and Day and Night
Divide thy Works no more,
My ever-grateful Heart, O Lord,
Thy Mercy shall adore.

III

Through all Eternity to Thee,
A joyful Song I'll raise;
For O! Eternity's too Short
To utter all thy Praise.

FINIS.

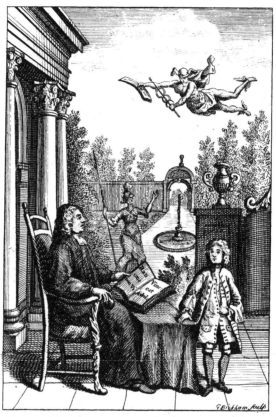

Happy the YOUTH, *who are* betimes *set right,*
And taught *the* Rules *of* VIRTUE *with* delight!
By foft Endearments *Generous Minds are won;*
By rigid Doctrines *very* Few *or* None:
The CYNIC TUTOR fruitlefs Lectures *reads:*
HE, *who* Gilds *ore his* Precepts, *beft* SUCCEEDS.

Original frontispiece